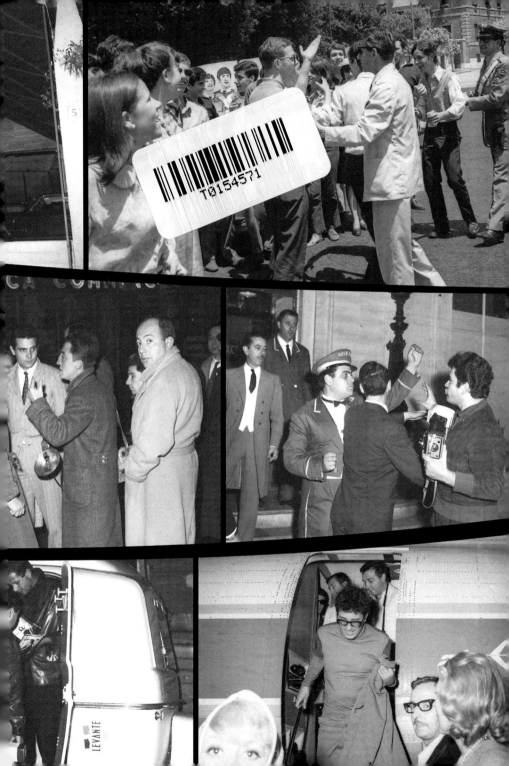

The Beatles in Rome
1965

Photographs

by

Marcello Geppetti

Manic D Press
San Francisco

Photography is a blade which, in eternity,
impales the dazzling moment.

— Henri Cartier-Bresson

Originally published in Italy by Azimut Press, Rome; Adriana Merola, editor.
www.azimutlibri.com

Beatles lyrics ©1965 Northern Songs.

Translation: Adriano Angelini
Design and production: Scott Idleman/BLINK
 Federico Romanazzo (Azimut edition)

Printed in the USA

Library of Congress Control Number: 2006936785

For more information about Marcello Geppetti, visit www.marcellogeppetti.it

Yesterday

Yesterday, all my troubles seemed so far away

Now it looks as though they're here to stay

Oh, I believe in yesterday

Suddenly, I'm not half the man I used to be

There's a shadow hanging over me.

Oh, yesterday came suddenly

Why she had to go, I don't know, she wouldn't say

I said something wrong, now I long for yesterday

Yesterday, love was such an easy game to play

Now I need a place to hide away

Oh, I believe in yesterday

John Lennon and Paul McCartney, 1965

Preface to the English Language Edition

Society's obsession with celebrities is endless. Newspaper racks are filled with magazines devoted to candid shots of movie, t.v., and music stars. What are the origins of this strange pursuit?

The current use of the term, *paparazzi*, is derived from a character in Federico Fellini's 1960 film, *La Dolce Vita*, a celebrity-chasing photographer named Paparazzo. In an era before zoom lenses and digital speed drives, a huge burst of light from an outsized flashbulb startled many unsuspecting stars. Marcello Geppetti and Tazio Secchiaroli were *the* original paparazzi, they invented the artform of unposed celebrity photography. Geppetti caught the essence of his subjects. He understood what made a photograph compelling, what made an image resonate.

In 1965, as part of a 12-concert, two-week tour of France, Italy and Spain, The Beatles played four concerts in Rome on Sunday, June 27th and Monday, June 28th. The concerts began at 4:30 and 9:30 p.m., and a press conference was also held on the 27th. It was the summer of *Help!*, and Beatlemania was at its peak.

Marcello Geppetti and The Beatles. Two of the greatest in their creative fields, at a cultural crossroads, before the youth culture moved on to psychedelia, and violence escalated everywhere. That last moment of innocence before all hell broke loose, captured by Geppetti, personified by The Beatles. According to Henri Cartier-Bresson, "Of all the means of expression, photography is the only one that fixes a precise moment in time. We play with subjects that disappear; and when they're gone, it's impossible to bring them back to life." Enjoy.

— Jennifer Joseph, Manic D Press

Art in the Thick of It

Mimmo Rotella, artistic innovator of Italian collage, once wrote that he was often impressed by city walls plastered with ripped handbills, photographs, and movie posters because he thought the art of painting was finished and that it was urgent to discover something new, alive, and immediate.

"That's why at night I enjoyed tearing these manifestos from the walls, taking them to my studio, combining them or just leaving them the way they were." It was the birth of collage: a provocation, a diversion, many young people were doing it at the time. A gesture that came from the streets.

The early '60s were full of passions and inventions. The visual arts scene was shaken by movements like Op Art in Europe, Pop Art in the States, and *Nouveau Realisme* in France.

During his daily walks Marcello Geppetti also breathed in this atmosphere, and honestly and directly tried to convey this certain reality in his work. He didn't avoid the grand occasions constantly tempting photographers but he lived through the camera's lens, impressing images on the negative, giving opportunities to minor realities or small situations that were not yet part of history.

It is not by chance that his photographic works are taught in university classes alongside Andy Warhol's, among those who significantly contributed to the history of art in the second half of the twentieth century. Surely, though, Geppetti remains one of the most underappreciated photographers of his time.

From 1954 to 1964, Marcello Geppetti was a *paparazzo* who, with Tazio Secchiaroli and others, contributed to creating the myth of *La Dolce Vita*. These photographers unmistakably changed the way we see things. They went beyond the motion-picture veneer, catching the human aspect of actors, and in this sense Marcello Geppetti gave us something special: his sensitivity brought us to a new place. His are the unforgettable images of the fire at Rome's opulent Ambasciatori Hotel, which depicted young half-naked tourists throwing themselves into the void to escape the flames, photographs censored and deemed obscene by the Roman Catholic Church.

The arrival of the Beatles in Rome in June of 1965, their concerts, these brief and unique events, all this for Marcello Geppetti — at that time — was of little importance: four English teenagers making girls scream with their shaggy haircuts and incomprehensible motives. And yet, he knew how to frame all the necessary elements for creating a myth.

The photographs we have chosen, and their sequence, reveal the strength, the heart, and the dedication of a reporter's hard work in the field. Following, waiting, shooting, developing. Just to be there when history was being made.

The setting is no longer *Via Veneto*, the street of *La Dolce Vita*, where everything happened previously, but all of Rome's streets and alleyways. Geppetti raced around on a Vespa scooter, with his inseparable Leica camera around his neck, from the unique strip of land known as the Piazza Barberini to the doors of the Villa Borghese; all of Rome's streets where, within a short

time, a different kind of history would take place: the *Anni di Piombo*, the years of Italian terrorist bombings.

And Marcello Geppetti was there, too, as always.

His collaboration with *Momento Sera*, Rome's daily evening newspaper, might be considered the high point of his photojournalism career. Unforgettable images, where the streets were dyed red, and white sheets covered dead, murdered bodies; and where the desperation on the faces, the horror, caused the observer's eyes to open wide.

In any case, always, in Geppetti's photographs, there exists *l'arte del segno*, the monochrome that emphasizes the time of close-ups, the time backstage, the time of seeming randomness of the images, the time of pain, and the end.

There one will see that "Photography," as Henri Cartier-Bresson said, "is a blade which, in eternity, impales the dazzling moment."

— Adriana Merola, Azimut Press

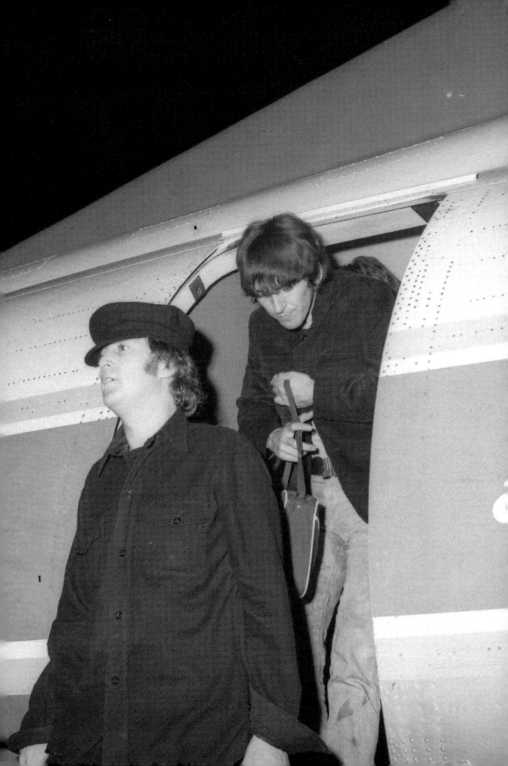

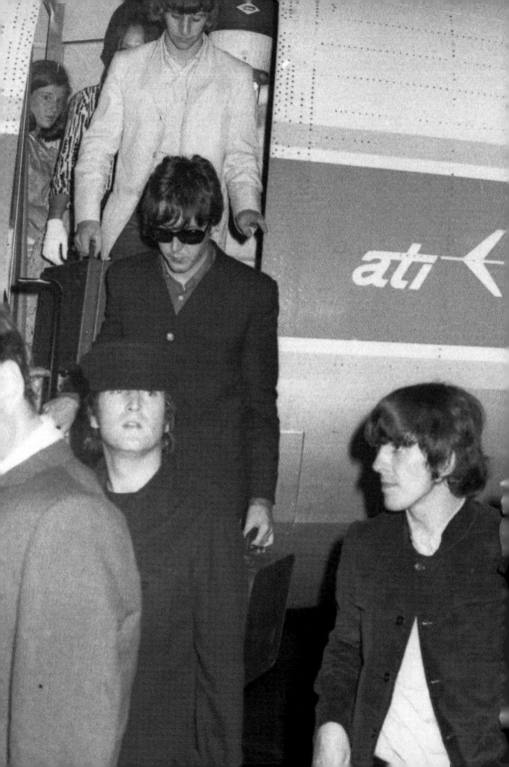

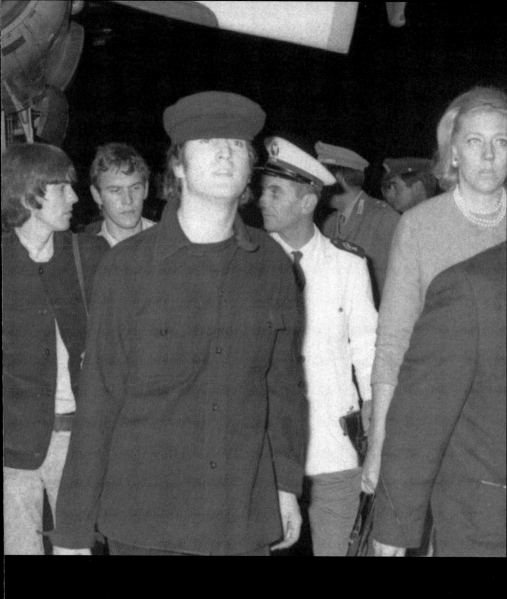

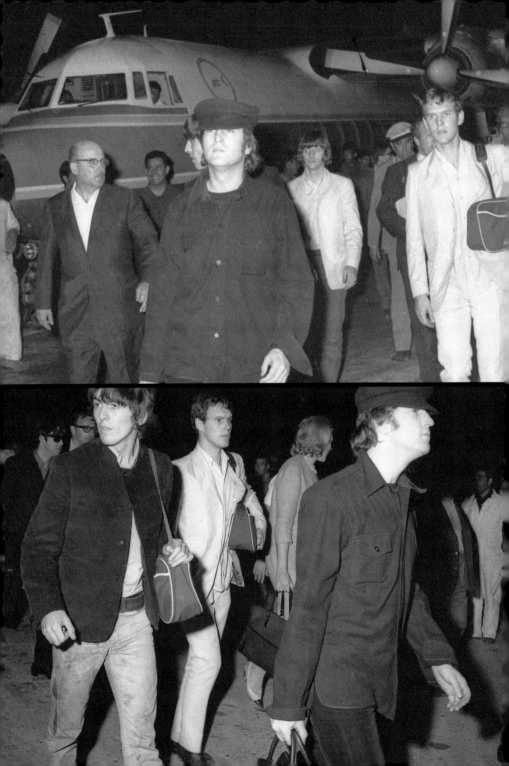

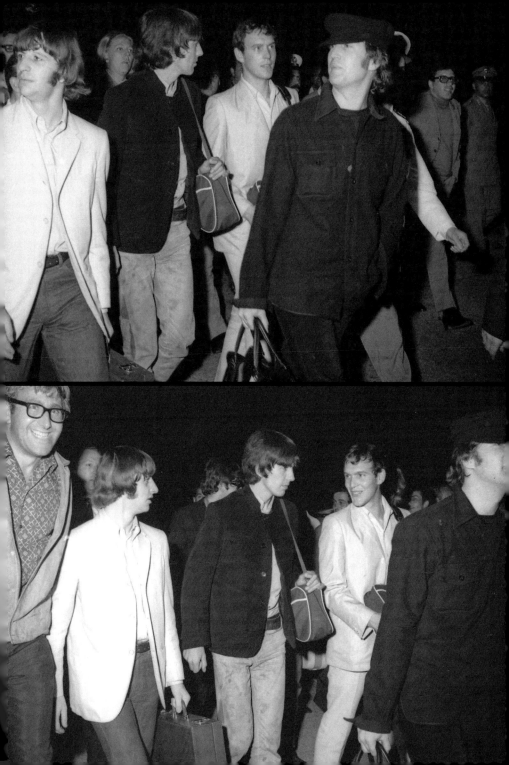

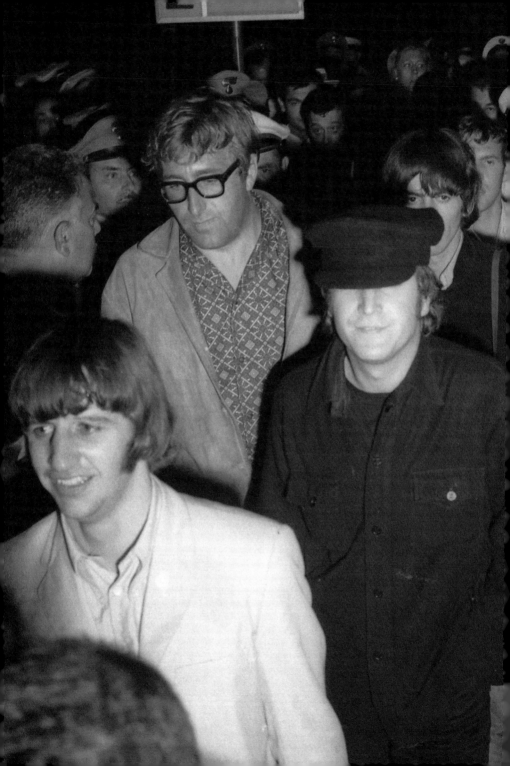

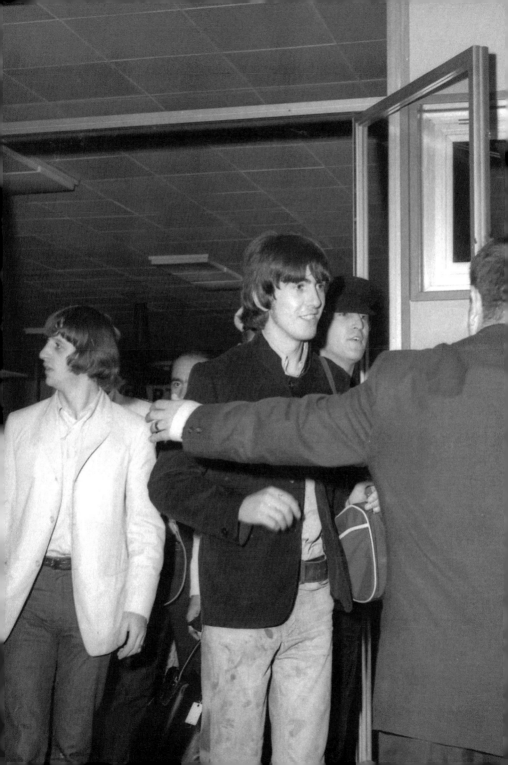

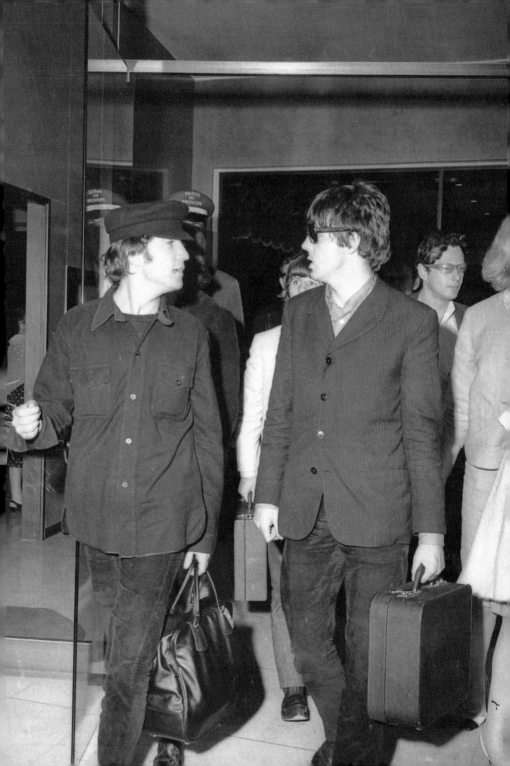

Ma Belle

Time, like Speedy González, brought with him, shrouded in a cloud, all those eyes staring at a Cliff Richard picture. The dusk came in through windows wide open. — Leopoldo María Panero

1965. The first thing I remember from that year is the Brazilian soccer player, Jair, kicking his ball. It was in Milan's San Siro stadium, the grass was wet, the ball slipped away from the hands of Costa Pereira, the Portuguese goalkeeper, leaving a trail of mud on his gloves. The second thing is the lit firecracker I put in the hands of a priest who offered me candies. The third one is the scream, the desperate orgasm, the fainting, the sense of loss of the Beatles' teenage fans worshiping their quartet of idols.

Cristi and Terese pop. The cross decayed and becomes a guitar, Bernini wants to be called John Lennon, only woman knows, like the famous poet says, the horror of life. But more than her is the girl who knows: fertility turned into a mere promise; unused to the mystical popular ecstasy; the oxymoron probable/could. Beat, beatitude, beetle. Hurt, with God on your side, the black-beetle! Vanish into the image. And the image that destroys the viewer, like in an M. G. Lewis tale, remains empty, blind in the twilight of a hard day.

We are talking about how the feminine, her infancy or feminine aphasia, tramples the beetle of her seeing and fainting: how the masculine, the Mark David Chapman, will appear iron-handed to the Madonna, to the icon of John Lennon, remarking his

own carnality, taking the place of all the metaphors: a good killer is a good sunset activator.

There is an abandoned house in time. There is a house where images are not protected by any casket of darkness. The figure gushes out in front of some eyes now gone, where are those eyes?

Where are the eyes that renounced their eyeball shape? Like a trail of mud, like an incredible flowing in one hand, the eyes said goodbye to their Madonna. They are not eyes anymore.

The curtain is ripped. The table is dusty. The doors off their hinges. The child has the tongue of a serpent. The photograph of Paul McCartney is subjected to vision without eyes. Oh Mother Mary, speaking words of wisdom, let it be.

We dance without drums, the music has the silence of the image, has the strangling of the image over the passing of time, *Je suis le ténébreux*, here comes the sun, *le Soleil*

Noir of this that I have forgotten. Ma belle.

— **Ianus Pravo, poet**

Parallel Passions

On June 24, 1965, I hitchhiked to Milan together with a friend to see the Beatles in concert. Since 1963 I had been a big fan of the Fab Four, but when I saw them on stage my enthusiasm skyrocketed. Though greatly excited, I was able to take a couple of pictures with my cheap Kodak Instamatic camera. The result was low quality images, but it was also my first photographic foray into journalism. Then came the Beatles' Genoa and Rome concerts. At that time, I loved to search for pictures of those events in all the magazines and newspapers I could read, and when I found the pictures of the concert in Rome at Adriano's Theatre, I was very impressed. I soon found out that they had been taken by a Roman photographer: Marcello Geppetti. There was something magical about them. The Beatles were framed by the old theater's structure where from time immemorial, great shows had taken place, and what a show this was! In that hot 1965, people were crazy for the Fab Four.

Marcello Geppetti's shots are an unforgettable memory of the experience. Their arrival at the airport, then at Parco dei Principi Hotel, where they stayed and held a press conference before playing the four concerts at the Adriano Theater. These are historical moments seen by Marcello Geppetti's eyes; imprinted in black and white and in our memories for forty years. His photos remain an example and a great lesson in the way to move, to frame a character, a scene, particularly for those who,

like me, after a few years became professional photographers: a difficult job but often gratified by unexpected results.

Indeed, Marcello Geppetti's camera not only captured the Beatles but thousands of famous people who arrived in Rome during that incredible period between the '50s and the '60s, called the Roman Fellinian *Dolce Vita* era.

Personally, as a Beatles fan and as a photographer working primarily in show business, I'd like to convey my gratitude to Marcello, a great master in the art of photography. A master of my profession, which I have pursued, together with a steadfast and true passion for the music of the Beatles, and that now more than ever is living inside of me through his memorable images.

Since I can no longer say thanks to him, I'd like to thank his son, Marco, who has given me the privilege to remember him.

— Rolando Giambelli, The Beatle People Association of Italy

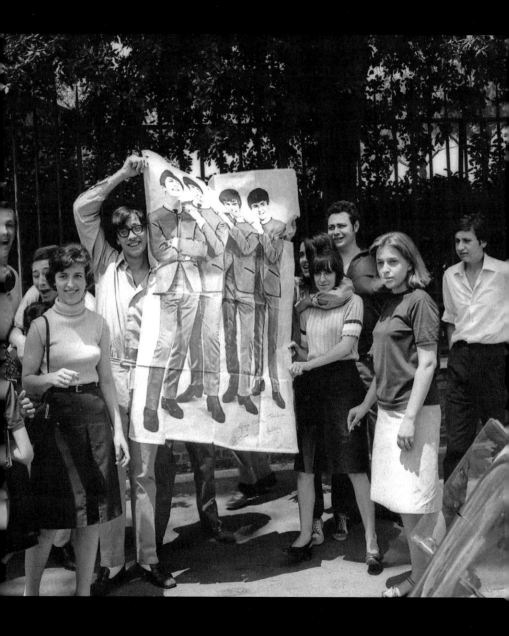

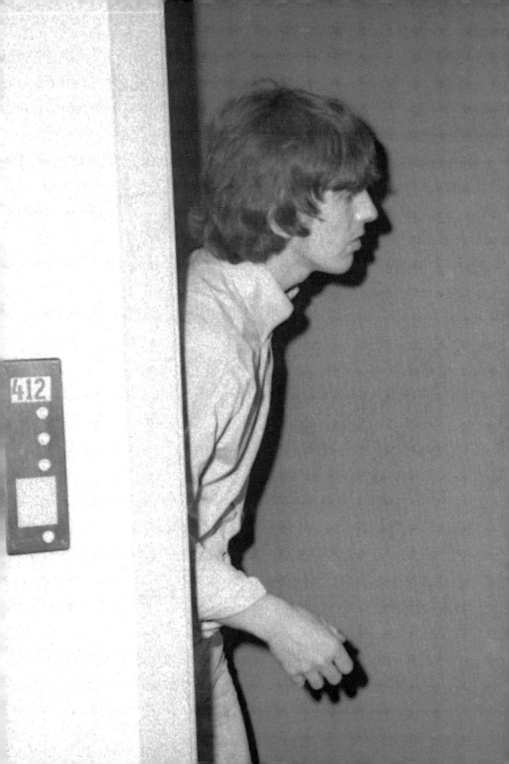

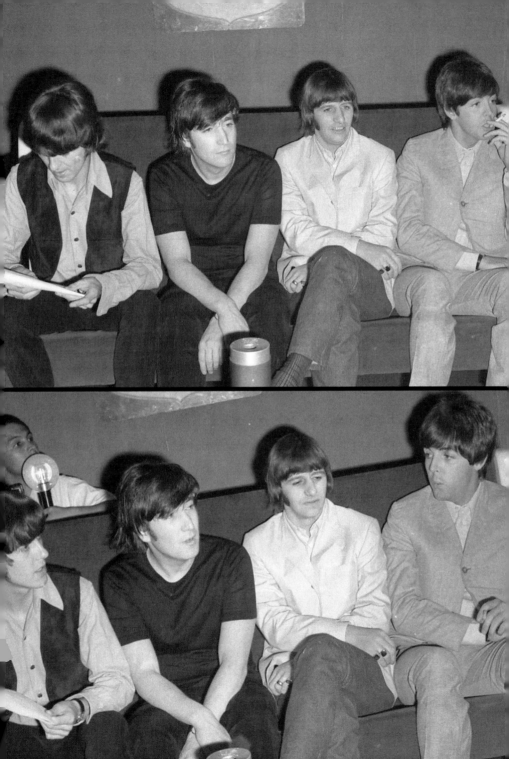

My Father

It was 1980 when a bullet hit John Lennon. I was 16, it was the '80s, and a new Beatlemania was affecting many teenagers who preferred not to follow the Paninaro style (the typical Italian teenage fashion celebrated by the Pet Shop Boys in their song) or the New Dandies, but went back to the tunes of the Fab Four. Timeless tunes, memories not yet faded. Me and my friends met in Villa Celimontana (a beautiful park in Rome near the Colosseum), where we listened to the Beatles on a cassette player. At that time, we read very popular teen magazines like *Ciao 2001* and Mauro Eusebi's *Nuovo Sound*. We also started a club, "Beatles Fans in Italy," and had a fanzine, too. I don't actually recall the Beatles years. I was a kid. Too small. For me, they were only four look-alike faces. Memories of them were so far away: one of the four wore round glasses, had a little beard; I also remember a cartoon with a submarine, and a videotape imported from the States called *Meet the Beatles*. In that famous Robert Freeman cover picture the faces all looked the same. Then there was a popular TV commercial for *Tè Ati* (a brand of tea), with a jingle my dad told me was a Beatles tune. It was fantastic. It was "Hey Jude." My dad owned the 45 record, too.

But let's go forward to the '80s.

At the beginning of 1981, when my heart and soul were full of love for music, and I started to understand that everything was born from them, my dad wanted to show me some photos he took in 1965: they were of the Beatles in Rome. Like all the great

photojournalists, he whipped them out of his library after John Lennon died; he wanted to give them to the newspaper.

From that precise moment, for me he was not only the great master of the art of photography, the artist who, together with the paparazzo Tazio Secchiaroli, created a lasting style, a new language in the journalistic world, underappreciated by history but rewarded by those who understood the art of taking photos. He was not only the author who captured Liz Taylor and Richard Burton's adulterous kiss, the tragic Ambasciatori Hotel fire, the unforgettable Anita Ekberg running after paparazzi with arrows and bow like an archer – when *paparazzo* was not yet an insult – the image of Raquel Welch dancing on a table as Marcello Mastroianni clapped his hands, the first nude picture of Brigitte Bardot. For me, he was also the hero who immortalized the Beatles in Rome.

I started to besiege him. I wanted him to print them for me. I wanted to show them to my friends at the fan club. They were the feather in my cap! I soon became the vice-president of the club. My friend, Amilcare, however, was still the president, and though he was busy, I forced him to spend long hours in the darkroom. After that, I became a photographer too.

In 1998, my dad died, leaving me a huge inheritance in the form of a photographic archive. I started to consider photography as an artform. I discovered his images again, seeing them with new eyes. Through his works, I understood the difference between an artistic photograph and a simple shot. That is to say, the difference between taking a picture of Liz Taylor and Eddie

Fisher walking together in the street, or taking a photograph of them through the window of a car, while he's singing a serenade accompanied on the violin, with a *Roman Holiday*-type of flower-girl in the background, on a beautiful *Dolce Vita* night. That was the fairytale and Liz was the enchanted princess. That was the difference, and my dad and Tazio Secchiaroli understood this.

But let's go back to the Beatles.

Only long after first observation did I notice the contact lenses in John Lennon's eyes, in the extreme close-up taken by my dad at the pre-performance press conference at the Parco dei Principi Hotel. The Beatles' manager, Brian Epstein, didn't want the world to know about his strong myopia. The round glasses would have come later, with *Sgt. Pepper*, or maybe a little before, with *How I Won the War*. Only Marcello Geppetti was able to see those lenses.

— **Marco Geppetti**

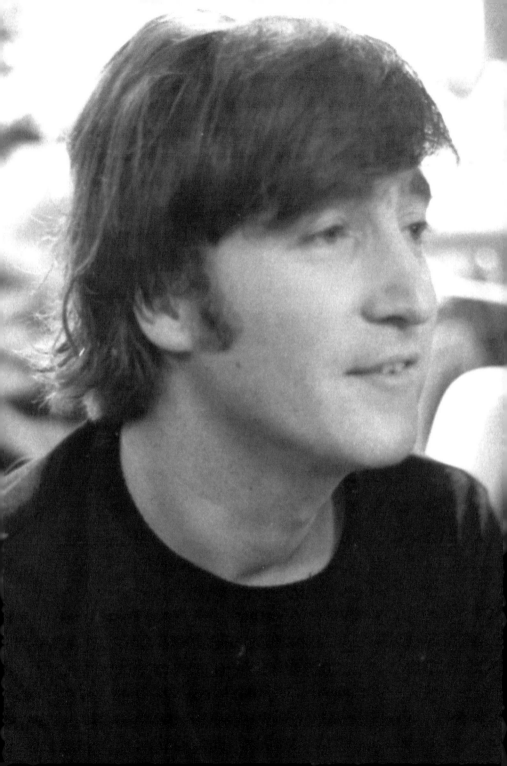

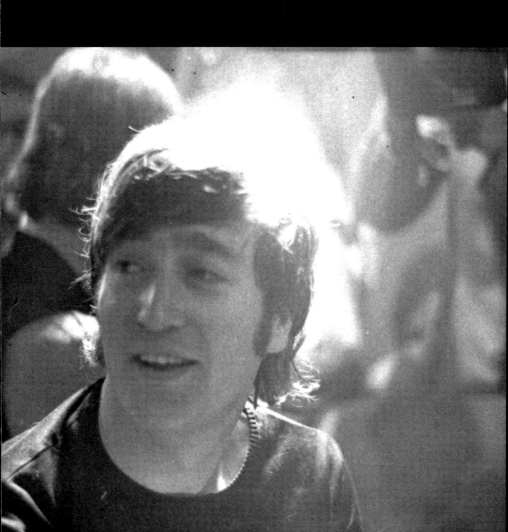

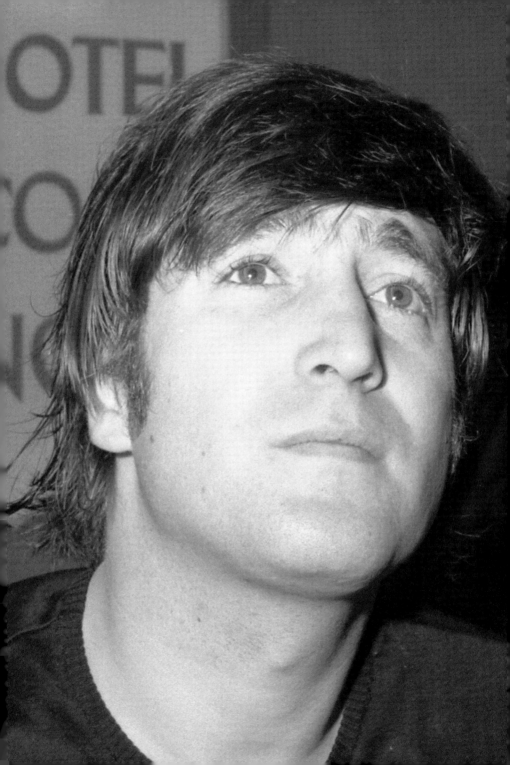

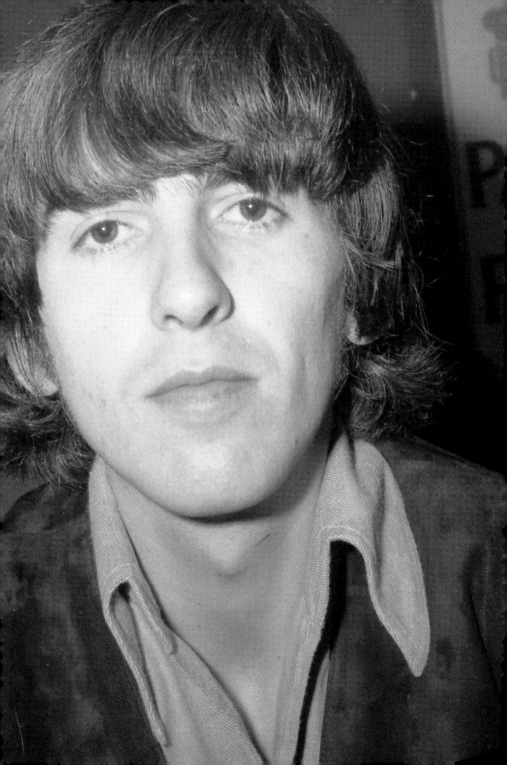

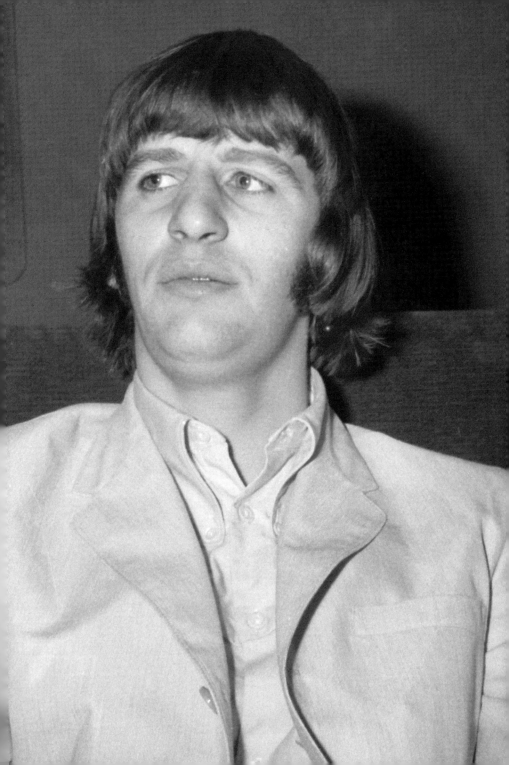

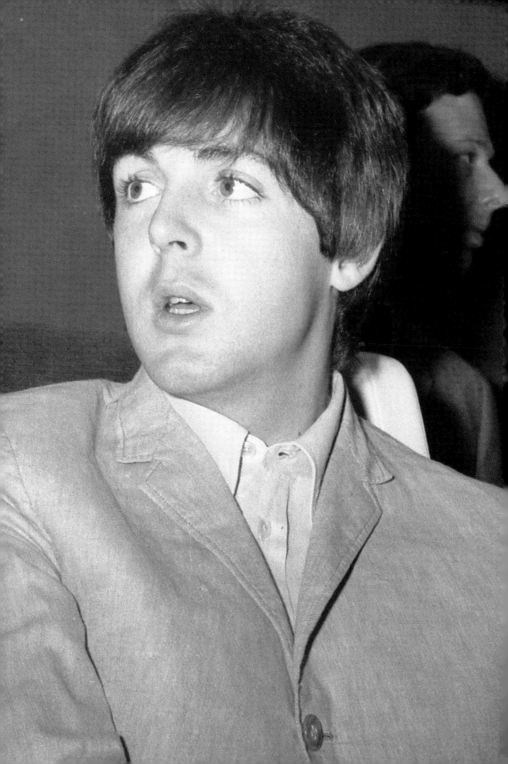

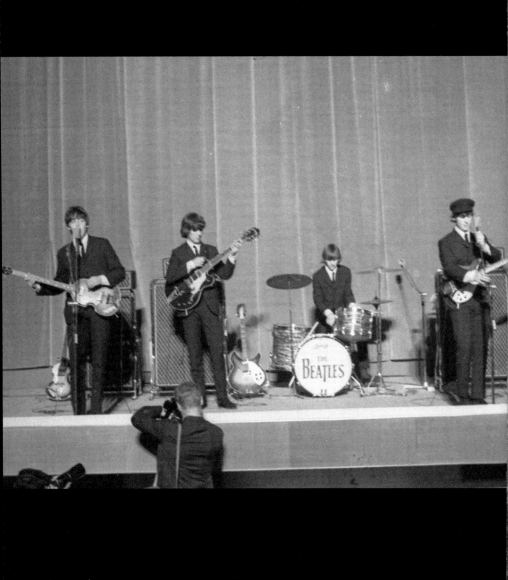

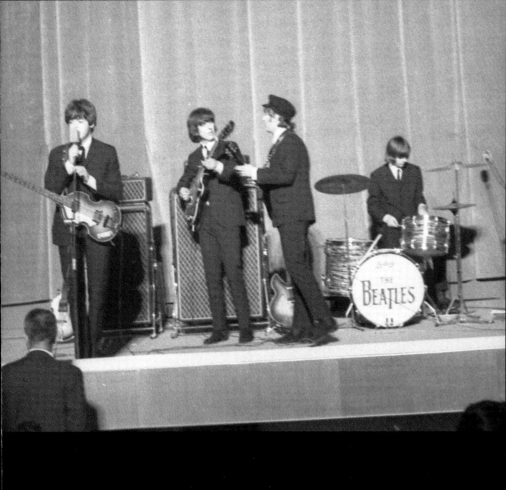

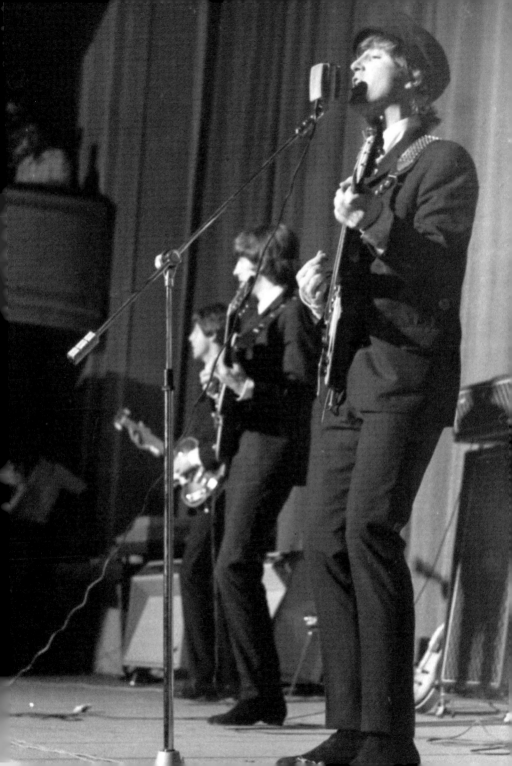

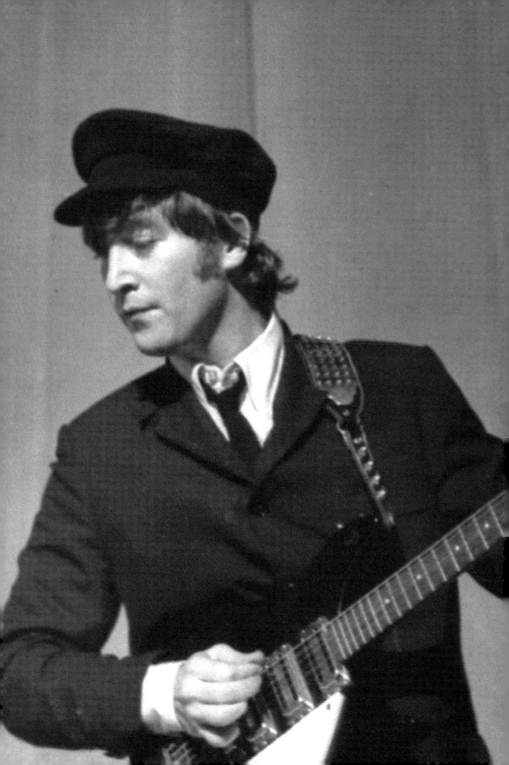

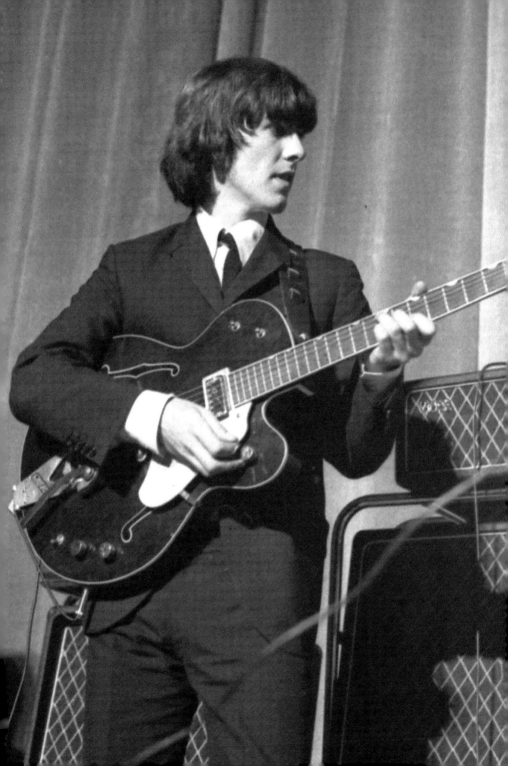

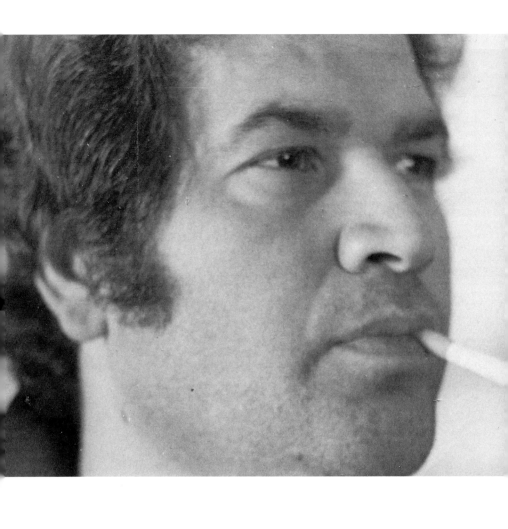

Marcello Geppetti

Marcello Geppetti was born in Rieti, Italy in 1933.

Geppetti was very young when he discovered his passion for the image and developed his own perspective about the things around him. His first job was at the Giuliani and Rocca photography agency where his photos were appreciated not only for their quality but also for the particular point-of-view they showed, revealing his talent for photojournalism. After that, he began working for one of the most important Italian agencies of the '50s, Meldolesi-Canestrelli-Bozzer. Then came the *Dolce Vita* years, his most successful period. Rome turned into an outdoor movie set, international movie stars naturally enjoyed walking along its streets. Marcello decided to work as a freelance photographer, beginning his collaboration with the Roman evening daily newspaper, *Momento Sera.* A few years later, when Italian terrorism began to seize the country, Marcello became the witness of those terrible events called *Anni di Piombo*. On February 27, 1998, he took his last photo, leaving an archive of more than one million precious images, including negatives.

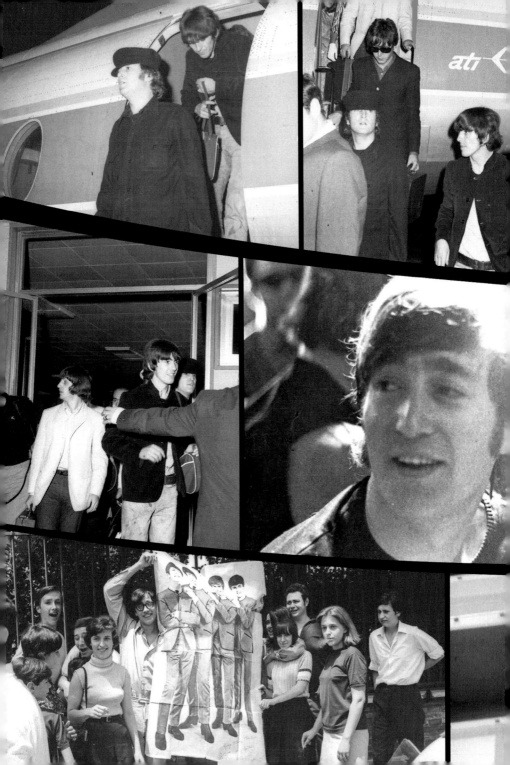